GW00818696

How to Get Great Type Out of Your Computer. Copyright © 1992 by James Felici. Printed and bound in the United States of America. All rights reserved. No part of this book may be reproduced in any form or by any electronic or mechanical means including information storage and retrieval systems without permission in writing from the publisher, except by a reviewer, who may quote brief passages in a review. Published by North Light Books, an imprint of F&W Publications, Inc. 1507 Dana Avenue, Cincinnati, Ohio 45207 (1-800-289-0963). First edition.

96 95 94 93 92 5 4 3 2 1

In the type samples and illustrations in this book, any similarity to real people, companies, logotypes or situations is strictly coincidental.

Adobe, Adobe Garamond, Display PostScript and PostScript are registered trademarks of Adobe Systems, Inc.

Antique Olive, Eurostile, Garamond #3, Helvetica, Simoncini Garamond and Stempel Garamond are trademarks of Linotype AG and/or its subsidiaries.

AppleTalk, the Apple logo, Macintosh and TrueType are registered trademarks and Finder, LaserWriter and QuickDraw are trademarks of Apple Computer, Inc.

Bembo, Gill Sans and Monotype Garamond are registered trademarks of The Monotype Corporation plc.

Bernhard Modern, Broadway, Century Oldstyle, Century Schoolbook, Cloister Black, Franklin Gothic and Park Avenue are trademarks of Kingsley-ATF Type Corporation.

Compugraphic is a registered trademark of Compugraphic Corp.

Futura is a registered trademark of Fundicion Tipografica Neufville SA.

IBM is a registered trademark of International Business Machines, Inc.

ITC Avant Garde, ITC Bauhaus, ITC Caslon 224, ITC Eras, ITC Friz Quadrata, ITC Galliard, ITC Garamond and ITC Kabel are registered trademarks of International Typeface Corporation.

LaserJet and PCL are registered trademarks of Hewlett-Packard Corp.

Presentation Manager and Windows are registered trademarks of Microsoft Corp.

Umbra is a registered trademark of Tetterode Nederland (Lettergieterij Amsterdam).

Varityper is a registered trademark of AM International, Inc.

Library of Congress Cataloging in Publication Data

Felici, James.
 How to get great type out of your computer / James Felici — 1st ed.
 p. cm.
 ISBN 0-89134-424-1 (pbk.)
 1. Desktop publishing. 2. Printing, Practical—Layout—Data processing. 3. Type and type-founding—Digital techniques.
 4. Microcomputers—Programming. I. Title.
 Z286.D47F443 1992
 686.2'2544—dc20

91-32470
CIP

Editorial Concept by Diana Martin
Edited by Mary Cropper
Design by Kristi Kane Cullen

PREFACE

This book started on the telephone. When I was an editor at *Publish* magazine, questions from puzzled readers about type and typesetting were always directed to me, and it quickly became clear that these folks were troubled by two things: their computers and the new world of typography. The people who knew type were having trouble getting quality results from their newfangled tools, and the people who were at home with their computers were scratching their heads over how to set the kind of type they'd seen in books and magazines. This book is for all those people.

There are no long lectures here, just simple instructions on how to get the job done. By following the tips presented here, you'll be able to set type like a pro—quick and slick. The bulk of the tips focus on creating quality type with a minimum of time and effort. For more information on the design aspects of type and typesetting, consult this book's sister volume, *Using Type Right*, by Philip Brady, also published by North Light Books.

Finally, I'd like to thank the people at Bitstream Inc. for generously supplying so many of the fonts used in creating the illustrations in this book. A good typesetting job starts with good type, and I greatly appreciate and value their contribution to my efforts.

James Felici
Fontès, France

TABLE OF CONTENTS

PREFACE

Chapter Seven
Beyond Text......................................79

Welcome to the world beyond the word—to wild ad type, exotic letterforms, and typographic decoration to spice up your pages.

Tips:

Chapter Eight
Composition Troubleshooting.........................91

No computer is smart enough to catch all the problems that can plague a typeset page—here's how to catch and fix the messes the type gremlins leave behind.

Tips:

Chapter Nine
Printing..103

The proof of the setting is in the printing. These tips are guaranteed to make your printing smoother, faster, and better looking.

Tips:

Chapter Ten
At the Service Bureau..........113

Why just laser-print your type when you can have it phototypeset like the pros do? Here's how to do it and save time and money.

Tips:

Chapter Eleven
Four Basic Concepts...............121

Here are four lessons your program manuals never teach you —the fundamental principles that underlie all computer typesetting. Knowing them will take the mystery out of computer typesetting.

Glossary..129

203 definitions that demystify the ancient jargon of type and the computer-speak that's invented as fast as we can figure out what it means.

CHAPTER ONE

SETTING UP

This chapter is about tools—how to assemble a matched set for working faster, easier and better. Especially faster. And you don't have to spend a lot of money to build a toolbox that will take the drudgery out of setting type. There's no sure way to avoid working overtime, but by following the tips in this chapter, you'll start off on the right foot.

Use the Right Computer

Setting type and building pages is one of the most demanding tasks for a personal computer. But this doesn't mean that you need the most powerful computer you can buy. What you do need is a fast microprocessor (the chip that's the "brain" of the computer) and a lot of memory (RAM) and disk storage to handle all the fonts, files and programs that are a part of desktop publishing.

Here are the minimum specifications for a good desktop typesetting computer:

Microprocessor
- *IBM-PC or compatible: 80286*
- *Macintosh: 68020*

Older IBM-PC-compatible models with 8088 or 8086 chips and older Macs with 68000 chips can serve as typesetting computers, but they'll work sluggishly (if at all) with newer and more powerful software. The investment in a faster computer will pay for itself quickly in the time it saves you.

Many current IBM-PC-compatible desktop publishing programs run only under Windows 3.0, the graphic operating system from Microsoft. To run Windows 3.0, you need a computer based on the more powerful 80386 chip. These machines are more expensive than 80286-based machines, but they're far faster and more powerful. It seems that Windows 3.0 and future versions of Windows will be the dominant operating systems of the future for IBM-PC compatibles, so the investment is probably a wise one.

For more speed (and a higher price), you can also get IBM compatibles with 80386 and 80486 chips and Macs with 68030 and 68040 chips, although you probably won't need that much power unless you are using a lot of complex graphic or photographic images. A PC with a 386 chip may be necessary to run some of the new and advanced operating system software.

Memory
- *2 megabytes (MB) RAM*

One megabyte may be serviceable, but the more information that your computer can hold in its memory, the faster it will run, and the more pleasant it will be to use. On the Mac, some desktop publishing programs won't run with only 1 megabyte of memory.

Disk Storage
- *One high-capacity floppy disk drive*
- *Hard disk of at least 20 megabytes*

Files of typeset text can get very large, especially if they include graphics. Having a lot of fonts at your disposal also takes up a lot of disk space, and typesetting and desktop publishing applications are quite large themselves. Consider buying a 40MB hard disk, which

is nowhere near twice as expensive as a 20MB hard drive. In general, bigger drives tend to be better buys than smaller ones.

Monitor

- *IBM-PCs and compatibles: VGA resolution or better*
- *Macintosh: Standard Macintosh monochrome monitor*

You have to look at the screen all day, so it may as well be easy on the eyes, and higher resolution means crisper, easier-to-read type on the screen. For typesetting applications, color is not a necessity—in fact, color monitors are often less sharp than monochrome ones when producing images of black-and-white type.

Full-page monitors are not only nice to look at, they're also great time-savers, eliminating a lot of time-consuming scrolling around the page. But they're also rather expensive. If money is tight, hold off on getting a full-page monitor, but seriously consider getting one at your first hardware upgrade.

Mouse

Most desktop publishing programs make the mouse a necessity. With a Macintosh, it's standard equipment. With an IBM compatible, you can buy a serial mouse, which attaches to a serial port in back of the computer, or a bus mouse, which has its own card that's installed in the computer. The latter type is faster and more responsive, if a bit more expensive. Always use a mouse pad—a specially designed surface on which to use the mouse. It keeps the mouse clean, reduces wear and tear, and makes your cursor movements smoother and easier to control.

#2

Use the Right Printer

The two main criteria for choosing a desktop laser printer are fonts and compatibility. You'll probably want the flexibility that outline fonts give you (see "About Digital Type" in Chapter 11), and if you will be exchanging files with other people, a printer compatible with a variety of others.

From these standpoints, the best choices are (for either PC or Macintosh) a PostScript-compatible printer or (for the PC) a Hewlett-Packard LaserJet III compatible that uses PCL 5.0 or a compatible *Page Description Language* (PDL)—previous versions of PCL don't handle outline fonts. Both types of printers offer outline font technology and a huge installed base of compatible machines. The LaserJet III can also be upgraded to accept PostScript files by adding a plug-in cartridge.

If you plan to print your files on high-resolution phototypesetters, PostScript is the way to go. Most major commercial typesetter manufacturers build PostScript compatible machines, and service bureaus that specialize in high-resolution printing of desktop-created files are numerous (see Chapter 11).

In regard to particular printer specifications, here are some recommendations:

Speed

The rated speed of a printer, measured in pages per minute, is the speed at which the motor of the printer can move paper. Real printing speed, though, depends on how fast the printer's image processor works, and complex pages will rarely print at a printer's rated speed. However, faster rated printers will generally print faster than slower ones. If your printer will be on a network and used by several people, a faster printer will cut everyone's waiting time. But if the printer is intended for your personal use, consider buying a slower printer, which will be cheaper, and using a print spooler (see Tip #6) to reduce the time that your computer is tied up during printing.

Memory

Get plenty. The more you have, the more room you'll have for storing fonts, and the faster complex pages will print. On both Post-Script printers and LaserJet compatibles 2 megabytes is a minimum. On a LaserJet compatible, you could start out with 1 megabyte and upgrade later if necessary, but buying add-on memory is more expensive than buying it installed in the first place.

Paper Capacity

If you have a choice, opt for a printer that has a large (250+) paper tray, especially if your printer will serve a network.

Resolution

Most desktop laser printers work at 300 dots per inch, and this is fine for most type above 6 points. Surprisingly, 400 dpi printers don't do that much better a job, even though they put 50% more dots on the page. Small type is more legible, and halftone photographs are somewhat clearer, but the added quality of a 400 dpi printer isn't usually in line with its added cost. At 600 dpi and up you begin to see marked improvements in type clarity. For ways to improve the clarity of 300 dpi type, see Tip #98.

#3 Word Processors Can Be Typesetters

You may not need a full-blown (and expensive) page composition program to set your type. Today's word processors can use the same professional fonts as more expensive typesetting programs. Consider these word processor pluses:

+ You need a word processor anyway—for preparing manuscripts, they're the right tool for the job.

+ Word processor files are far more compact than composition program files, which can be several times larger than word processed files containing the same number of keystrokes.

+ Most word processors can import graphics.

But word processors also have their shortcomings as competent typesetting tools:

– Word processors offer very little hyphenation and justification (h&j) control (see Tip #61).

– Word processors typically lack kerning and tracking capabilities.

– Word processors have limited page makeup capabilities such as creating complex column structures.

– Word processors offer few controls over graphics once they're imported into your pages (they are, after all, *word* processors).

Nevertheless, many commercial book publishers now use word processors to set the type of some of their books, especially inexpensive paperback editions. Word processors work best for setting type when measures are wide (which mitigates their shortcomings at h&j) and when column structures are simple (preferably one column per page). For reports and other documents with simple layouts and modest typographical demands, try your word processor first—it may be just the right tool for the job.

#4 Make Sure Your Programs Get Along

The key to composing complete pages is making sure that all of your programs can contribute effectively; that is, that they're *compatible* with each other. At a minimum, make sure that:

● Your word processor can pass fully formatted files to your page composition program with all formatting intact.

● Your page composition program can export text in a file format that can be read by your word processor (preferably that word processor's own format).

● Your graphics programs can use the same fonts as your word processor and page composition program.

● Images created in your graphics programs can be used by your page composition program.

#5 Make a Leading Gauge

A good leading gauge can save you a lot of time and effort. With it you can quickly deduce the specifications of a passage of typeset text, figure out how many lines of type at a given leading will fit on a page, verify alignments and settings on your own printed pages, and perform a host of daily typographic chores. They are so useful that they will almost certainly disappear from your desk.

You can make a leading gauge in about an hour, and once you have the file on disk, you can print up new ones as fast as they disappear. Print your gauges on clear acetate that's made specifically for use in photocopying machines and laser printers—it's available at all office supply stores (see Tip #7).

The gauge illustrated here has a point scale on the left, a pica scale on the right, and 8 columns of leading ranging from 6 to 13 points. When creating your own gauge, indicate the lower leading values you use most often; these values can be doubled to measure display type leading. Here's how to build the model shown:

1. Specify the page as having 10 columns with a gutter width of 0 and 3-pica margins on all sides. You'll need one column for each pica ruler on the outside edges and one each for the 8 leading rulers. Gutters are unnecessary.

2. Set ruler guides at 24-point intervals from top to bottom of the page, aligning the top one at a whole pica tick-mark on the screen ruler.

3. Assemble the point scale on the left margin in the 200% page view. You will have three kinds of tick-marks: short—10 points long, set every 2 points; long—18 points long, set every pica; and medium—14 points long, set every ½ pica. All the rules on the gauge should be hairlines or ⅛-point rules. With tick-marks at every 2 points you can still measure with half-point accuracy.

 Draw a set of the first 6 ticks: 1 long, 2 short, 1 medium and 2 short. Group these rules, copy them, and then with repeated "paste" commands duplicate them and position them one under the other, all the way down the page. This copy-and-paste routine saves a lot of time and effort. Or, if your program has a step-and-repeat feature (for automatic duplication and positioning of repeating items), use it to create 44 more of these 6-rule units.

4. In their own column, set a column of numbers that correspond to the tick-marks, in increments of 12, with each number on its own line followed by a carriage return. When the column of numbers is complete, specify the type as 8-point Helvetica on 12 points of leading. Move the column into position with the numbers centered on the long, pica tick-marks.

5. Build the tick-marks for the 6-point leading column the same as step 3, making all the marks 24 points long. Set a few with great care, and use the copy-and-paste (or step-and-repeat) technique to duplicate them down the page. If your first set of rules is precisely placed, and you paste accurately, you can't go wrong.

6. Build the other leading columns the same way. Then set a column of numbers the same as step 4, but count by ones. Specify the type as 6-point Helvetica on 6 points of lead. Place this column next to the 6-point tick-marks, and copy the whole column of numbers. Paste it next to the 7-point tick-marks and change the leading setting to 7 points. Do the same copy/paste/adjust-the-leading routine for the other columns.

7. For the pica ruler at the right edge of the gauge, copy the tick-marks of the point ruler from the left side, and adjust the pica tick-marks to create a perfect mirror image of the point scale. Or, if your program allows it, just make a mirror image of the point ruler. Copy the numbers from the 12-point leading column, specify them to set flush right, and slide them into position next to the pica tick-marks.

8. Add the labels over the leading columns, and you're finished.

You can customize this basic leading gauge (not shown to scale) by adding type samples (for instance, an uppercase *E* and a lower case *z*, known also as a letter scale) in several faces and sizes at the bottom of the gauge. With these samples you can measure the type in printed text. Try setting samples in the basic text sizes (9 through 14 points) and an assortment of display sizes. Good faces to use as samples are Helvetica (the ubiquitous sans serif face) and Times Roman (the classic serifed face). You may also want to add some samples of rules in basic weights from hairline to 12-point.

#6

Use a Print Spooler

Using a print spooler is like having someone else stand in line for you at the bank—you're freed up to spend your time more productively.

Normally, when you ask your computer to print a typeset document, it feeds it to the printer one page at a time, and the printer in turn creates an image of each page, and then prints it. While the printer is doing this work, the computer is twiddling its thumbs, and so are you.

A print spooler is an inexpensive program that acts as an intermediary between the computer and printer—a holding bin from which print jobs are fed out to the printer. Your program very quickly passes your job into the spooler, and the spooler takes care of spoonfeeding the printer while your program is freed up, letting you get back to work. Print spooling is an example of background processing—a computer action that takes place invisibly while you're busy doing something else.

#7

Use the Right Paper

Desktop laser printers are based on the same mechanisms used in photocopying machines, so any printing surface approved for use in photocopiers should work in your laser printer.

Cheap photocopying paper is the most economical. If you plan to print on only one side of the sheet, any stock of photocopy paper is fine. If you plan to print on both sides, pick a stock that will be opaque enough to keep the print on one side from being visible on the other.

Many paper manufacturers also sell papers specially made for laser printing, and these are typically coated and mechanically smoothed to give you the crispest possible image. These papers are also resistant to glue and hot wax, the two adhesives commonly used for hand paste-up work. Either of these adhesives may soak through thinner uncoated stocks. Special laser papers, though, are expensive, and often the image they produce is *too* good. That is, the image is so clear that you can see all the jagged stair-step effects on diagonal lines and letters in 300 dpi type, where individual dots are big enough to be clearly visible. Cheaper, rougher paper, ironically, tends to muddy these edges a bit and may actually give your type a smoother appearance.

You can also print on clear acetate with your laser printer, which is a good way to make type and leading gauges and images for overhead projectors. Make sure any acetate you buy is specifically rec-

Custom Hyphenation

When you add or change a word in your program's hyphenation dictionary, you've changed how your program composes text. From that point forward, you run the risk of having your text compose differently from everyone else in your group. If you pass one of your files to someone else who has a different hyphenation dictionary, they may get different line breaks than in your program because each program recomposes your pages every time you open the file. Once that file leaves your machine, it typically has no recollection of your hyphenation dictionary, relying instead on the one that's in the new computer it's running on.

If you're working on a network and your program allows it, you can opt to have everyone in your group work from a common dictionary that's stored on the server—clearly the simplest solution. Alternately, you can keep a record of additions and changes you've made to your dictionary and share them with the group so they can update their own dictionaries, or if your program allows, simply have group members copy the updated dictionary.

#18 Protect Your Shared Resources

Everyone in your group should have easy access to the same sets of templates, style sheets, fonts and lists of tag names. On a network, the best strategy is to put all of these resources in a common directory or folder on the network server. They should be stored in *read-only* format—that is, they should be locked so that members of your group can copy them but not alter or delete them. When changes to any of these files are made, everyone should be notified.

Because templates and style sheets evolve, everyone should copy from these originals whenever they create a new document. Users will be tempted to copy templates and styles from previous documents stored on their own hard disks. This can create an evolutionary backwater, where an individual's formats are cut off from the developing styles and formats of the group.

#19 Check the Paper Tray

This sounds painfully obvious, but a perverse fact of life with a networked printer is that it only runs out of paper for you. Everyone else can print without incident, but when it's your turn to print, there isn't any paper. If everyone takes a glance at the paper tray when they pick up their work and fills it when necessary, one minor irritant will be removed from your workday.

Tips for Mixed Networks

Networks enable Macintoshes and IBM-PC compatibles to coexist peacefully and cooperatively, but life on a mixed network is not all a bed of roses. Here are some particular thorns to look out for and precautions to take:

- Mac file names will be abbreviated on the PC. When you move a file from a Mac to a PC, the name is apt to truncate to meet DOS file name conventions, so Macintosh files named New Text 1 and New Text 2 may both appear on the PC as NEW_ TEXT.TXT (word spaces, which are illegal in DOS file names, generally become underscores), and because they have the same name, one file may overwrite the other.

- Files moved between Mac and PC are copied, not just translated. This means that you're creating two versions of the same file on the network. When a file is moved from one machine to the other, both files must somehow be identified—either by location, file name, or most current version—as existing in both worlds. This will prevent, for instance, someone continuing to edit a Mac file even after it's been moved to the PC for composition as part of another document.

- Identical fonts have to be used on both machines. Unless either the Mac or the PC is to be used exclusively for raw manuscript preparation, both machines will have to use identical fonts.

If the Mac and PC share a printer, they may need only one set of printer fonts. For example, if all of the fonts you need for printing your jobs can be loaded into the printer at the same time, they could be loaded by either a Mac or a PC, and you need buy printer fonts in only one of those formats. In this scenario, the Mac could download the fonts for the PC to use, or vice versa. If printer memory is limited, and fonts have to be automatically downloaded, you must invest in duplicate fonts: one set for the PC and one for the Mac so each can do their own automatic downloading. Given the cost of fonts, it may be cheaper to invest in a printer that can accommodate all the fonts you need and avoid redundant font purchases. In any case, you'll need screen fonts for both machines, although these are usually free or very inexpensive (see Tip #46).

Because the fonts you'll be using need to be identical, this precludes creating custom kerning tables using special kerning programs or font editors unless they work on both Macs and PCs. Kerning adjustments built within composition programs, though, will work fine as long as the font itself is not altered.

- Use programs that exist on both platforms. You'll have the best results if you use word processors and composition programs from manufacturers who sell both Mac and PC versions of those

programs. When a program exists in both versions, files can almost always be exchanged between them with very little effort or touch-up needed. The effort these programs save is worth any added expense they may involve.

- Exchange graphic files in Encapsulated PostScript Format (EPSF) (see "Page Description Languages" in Chapter 11). If you're working on a mixed PC/Mac network, you're probably using a PostScript printer, so your best bet is to exchange graphics files in EPSF. Handling your graphics in a standard way makes their behavior more predictable and the EPS format can be read and handled by all major composition programs.

- Beware of moving highly formatted files between Macs and PCs. The Macintosh and PC agree on the first 128 characters of the ASCII character set, the so-called low-bit characters. These include all of the characters that you can access directly off your keyboard—the typewriter characters, more or less. But the high-bit ASCII characters are many of the popularly used typographic characters, including em and en dashes, typographic quotation marks, accents and so forth. In file translations between Macs and PCs, these characters may become lost in the sauce. How these characters are mistranslated, though, is generally consistent, allowing you to create a standard set of search-and-replace procedures to fix most of the damage. A quick once-over with a spelling checker will find the rest of the miscreant characters.

- Page orientation
- Screen display options
- Printer setup

Other, more specific default values can be associated with specific templates. These include:

- Page margins
- Widow and orphan controls (see Tip #85)
- Hyphenation controls
- Choice of style sheet
- Default rule weight
- Hyphenation and justification specifications

Clean Up Your Manuscripts

It's a good idea to give all incoming manuscripts a once-over with your program's search-and-replace utility before investing a lot of time formatting them. Things to search for include:

- Double word spaces (run this search until your program tells you it can't find any more—on the first pass, triple word spaces, for instance, will be reduced to double word spaces that need to be weeded out on the next pass)

- Unwanted tabs (authors often use the tab key for creating paragraph indents)

- Multiple carriage returns

- Manually added page numbers

In addition, just because you receive a file in ASCII format, don't assume it's ready to use. It's a good idea to screen all ASCII files, especially if they've come to you over a modem or via a file-translation program (see Tip #8). The main culprits to look out for are improperly converted characters and superfluous carriage returns.

Improperly converted characters are generally high-bit ASCII characters for which there are no standard keyboard assignments across the wide range of computers that may be sending you text (see Tip #20). Most of these characters (such as badly converted quotation marks, apostrophes and accents) can be located with a quick scan using your word processor's spelling checker.

Carriage returns are often inserted at the end of every screen line by telecommunications software and less-than-competent file-translation software. These programs typically leave two carriage returns at the end of every paragraph (adding another to the one that's already there). To correct this, use your search-and-replace program to search for two consecutive carriage returns (signaling

the end of a paragraph) and replace them with some odd character combination such as a double question mark. Then use the search-and-replace to eliminate all carriage returns.

#28

Save Complex Work

When you've spent a lot of effort on a complex or time-consuming formatting task, save your work so it can be recycled. If your program can't automatically build fractions, for instance, and you have to make them by hand (see Tip #68), save them in your program's glossary or notepad for future use.

If these elements are used in only one particular kind of document, you may be able to store them on the pasteboard area of your program's screen (if your program offers one) in the template associated with that document. From the pasteboard area, you can copy them easily into your pages.

Another strategy for recycling your formatting work is to create a macro that can re-create the formatting at the stroke of a key (see Tip #10). This is particularly useful for repetitive formatting where even copying and pasting can be too time consuming.

Also, remember that text doesn't have to remain text forever. A complex logo or other type element can be created in a graphics program or saved in a graphics format. In this way, the whole text

This newsletter logo was saved as a graphic, which makes the entire thing into a single image instead of an arrangement of individual words. This allows the logo to be scaled to different sizes for different purposes (front page, inside pages, letterhead, etc.) and prevents any of its constituent elements from being inadvertently changed or jostled out of alignment.

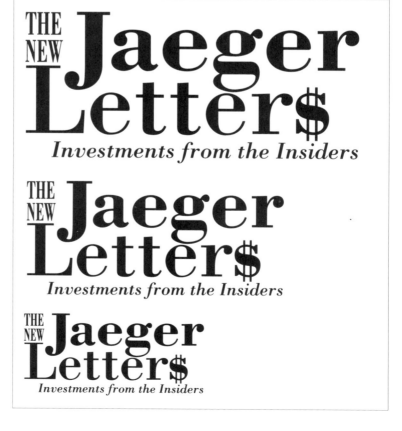

entity can be moved with ease and scaled to new sizes without having to build it again from scratch in all new point sizes. This also keeps the work from being accidentally altered or knocked out of alignment.

#29 Save Your Intermediate Takes

As you work on your publications, save them occasionally under different names, perhaps numbering them to indicate the evolution of the document. A cruel fact of computing is that files can become corrupted—that is, they can be flawed in some fatal way that prevents them from being opened or used again. This can happen if the computer fails to copy a file correctly, if the disk the file is on becomes damaged, or if a power failure occurs while you're working on the file. Such fatal damage is rare, but it's easier to go back to a previous version (or "take," as they say in the typesetting biz) than it is to start over from scratch.

Once your publication is complete, archive it along with the original versions of its text and graphic files for future reference. When the finished document is safely put away, you can dump the intermediate versions.

#30 Don't Be Afraid to Start Over

When you receive a manuscript that's been inconsistently or poorly formatted—or whose formatting doesn't exactly match your standards—it may not be worth your while to wade through it trying to tidy it up. There are likely to be too many changes to make without several proofreading passes to spot them all. Sometimes it's easier to just wipe out all the existing formatting and start over using your own style sheets (remember to save a copy of the original file first, for reference and comparison if need be). This is apt to be faster and less frustrating than trying to clean up someone else's mess.

If the file was created using the same composition program as yours, it may be worth exporting the file from your composition program and letting your program tag the file as it exports it. (Just as you can import text into a word processing or page composition program, you can export it back out as well, changing its file format at the same time, if you wish.) You can then examine the tagged file to see how the original file was formatted. This may expedite your salvage efforts by enabling you to see which passages have been badly or inconsistently formatted and to enable you simply to alter tag definitions to bring all the document's specs into line.

Build Pages in Spreads

If your publication's pages will be printed on both sides, you should have your program display pages in spreads, so you can see facing pages on-screen just the way your reader will see them after they're printed. Even at a very small size, this highlights any imbalances or unwanted symmetries in the composition of the spread as a whole—problems that are almost impossible to detect if you were viewing pages one at a time. Working in spreads also makes building your master pages easier, because the right-hand page can be assembled more easily as the mirror image of the grid on the left-hand page.

Binding Margins

Unless your pages are going to be handled strictly in a looseleaf fashion, you'll probably want to build binding margins into your pages. Even office documents should have some kind of binding margin that's wider toward the binding edge than the outside edge of the page. With a proper binding margin, the pages can be drilled for a three-ring binder, mounted in a clamp-on binding or report cover, or bound using an office binding machine without having your type sliding unreadably down into the binding. Your program's master page option will enable you to create asymmetrical binding margins so that your right-hand pages will have a wide left-side binding margin and your left-hand pages will have their binding margin on the right.

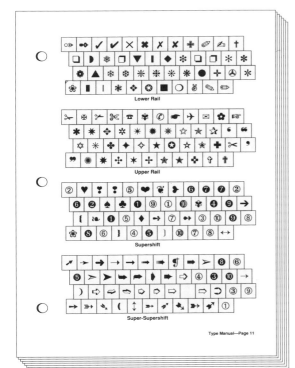

A binding margin pushes the page image toward the outside of the page, keeping it out of the binding and making the page easier to read. Here, the margin has been made wide enough to accommodate the holes drilled for use in a three-ring binder.

Build Small Pages Two-Up

When building small pages, consider ganging two pages on each typeset sheet of paper. This will save you time when composing pages (less flipping between pages) and it saves paper as well. To build pages *two-up* (as it's called in the printing trades), first choose a landscape (horizontal) orientation for your pages. When you set your page margins you'll be defining the outside, top, and bottom margins of two pages at once, but you won't be defining the inside margins—you'll have to do that by hand. When calculating the inside and outside margins keep in mind that you'll want to leave a gap between the two pages, as shown in the illustration.

Because both pages of each spread are actually printed on one piece of paper, build your grid for both pages on the same master page and indicate to your program that you'll be creating one-sided pages. This gives you just one master page, but one that contains master guides and elements for both left and right pages. After that, construct your pages as usual, and give both pages a set of registration and crop marks.

When building pages two-up in this way, there a few things to watch out for:

- When printing landscape pages, the raster image processor (see "About Digital Type" in Chapter 11) of your printer is rotating the entire page image by 90°—it's basically printing your page sideways. This rotation is a very complex computing job, and it will slow down your printing somewhat. On all-text pages, this slowdown isn't very dramatic, but if your pages include a lot of graphics—especially bit-mapped graphics—your pages can take a long time to print. For more about the perils of printing rotated pages, see Tip #92.

- Doubling up pages may confound your program's automatic page-numbering. Not all programs look at page-count tokens (the symbols that trigger the automatic page numbering) in the same way. Some will increment the number every time one pops up—giving you a proper numbering scheme no matter how many pages you build on one sheet of paper—but other programs number according to *their* definition of a page, not yours. Putting two of your pages on one of the program's pages does not make any difference to these programs—they still see only one page, and number accordingly. This will give both of your two-up pages the same folio because they are both on what the program considers to be the same page. The only fix is to set the numbers manually.

● Some print shops don't want to print pages two-up. For them, two-up pages mean more work cutting up film—it depends on how they prefer to do their camera work. Check with your print shop to see how they'd rather receive your camera-ready copy.

These pages have been built two-up on a single landscape-oriented, laser-printed page. When you set pages two-up, make sure that there's enough space between the pages to allow them to be cut apart easily without losing their crop marks.

on all opening pages and cover sheets of all corporate documents. If documents are being prepared using corporate stationery, use style *Memo / b*, which is intended exclusively for this purpose. Do not use style *Letter 6a*, which is intended for general correspondence use.

When using the corporate logo on internal reports, it should be rendered in black and white only. Paper color may be varied as detailed in the regulations in *Chapter 12—Color Coding of Internal Communications*. On such reports the logo should be reproduced in Size 6 (see *Section One* of this chapter for the list of stock logo sizes) if the page is 8½ by 11 inches (standard letter) or 8½ by 14 inches (legal). If the pages are printed two-up on a standard or legal size sheet, size 4 is the largest logo that should be employed.

Use of Color with Corporate Logo
When commercially printed, the corporate logo should only be rendered in black, as a 60% gray screen at 120 lines or more, or in the approved corporate color, PMS 561, commonly known as CorpCo Corp. Green.

When color copies of the logo are being distributed to the media, as with press releases and copies of our annual and quarterly reports, these logos should be *Logo Type B2/a* (see *Section One* of this chapter), the so called *Rainbow Logo*, which features the sun rising beneath a wide rainbow over which the corporate logo in midnight blue (PMS 262) has been superimposed. This logo should be made available in 3-by-5-inch transparency style or 35 mm slide according to notes appended to the media

database entries for each publication or broadcasting entity. For black-and-white publications, the screened version of the Rainbow Logo *(Type B2/bw)* should be supplied as an 8-by-10-inch or 4-by-5-inch glossy photos, according to the database information.

The logo should not appear in color on uncoated paper in sizes smaller than *Size 3*, because the logo begins to lose crispness. On coated stocks, the Rainbow Logo may be used in all available sizes.

Custom Logotype Sizes
The corporate logo should not be used in any sizes not outlined by in *Section One* of this chapter without written approval of the Vice President of Logotype Development, Use, and Implementation and without having the custom size signed off on by the Chair of the Sub-Committee for Corporate Image.

Custom logotype sizes should only be necessary under unusual circumstances associate with advertising, marketing, unusual publishing ventures, and extraordinary promotional efforts. In the past, non-standard logotype sizes have been approved in the following instances:
• Blimp advertising
• Give-away beach-blanket promotion
• Triple gatefold ad in Lubrication Illustrated
• Lick-on tattoo promotion at Playland-on-the-Fen
• Embroidered managers' cap logo
• Chairman's golf-club head covers
The approval period for a petition for custom logo size is typically eight to ten weeks due to the meeting schedule of the Sub-Committee for

CHAPTER FIVE

FONTS, FACES AND CHARACTERS

Fonts are the raw materials of typography—they deliver the multitude of characters and symbols in the myriad designs called typefaces. This chapter focuses on aspects of fonts and characters that your program manuals never tell you: how to save time and effort in selecting, managing and using your screen and printer fonts, and how to take advantage of some of the little-known and offbeat characters and symbols these fonts make available to you.

#48

fiddlesticks fiddlesticks
flim-flam flim-flam
fluffery fluffery
waffling waffling
raffia raffia
Æschylus
Œdipus

In these pairs of words, the spacing problems visible in the left samples are cured at right by using ligatures, compound letters that gracefully accommodate the colliding letters. The vowel ligatures below them (called *diphthongs*) are used mainly in historic and academic text.

Ligatures: Ties That Bind

Ligatures are two letters fused into one, and they are commonly used where the shapes of the two letters cause them to touch each other even in normally spaced type. The most common ligatures are fl (for fl) and fi (for fi). In both these cases, the *f* reaches far enough over to tickle the letter to its right, and the dot at the end of the *f* often overlaps the dot of the *i*, creating a lumpy, unsightly connection.

If your program can do it, have it automatically place ligatures for you as you type or import text. If your program can't do this automatically, use your program's search-and-replace function to do it quickly after all your text has been finally edited. Note, though, that because ligatures are narrower than the two or three letters they replace, they may cause your text to re-rag itself in some instances.

Never use ligatures in display type, though, such as headlines or titling text. If the dot of an *i* collides with the character next to it, you must either kern to compensate (see Tip #62) or consider using a *dotless i* (see Tip #49) if it's acceptable to the editor.

#49

Leaving Your i Undotted

Most fonts offer a *dotless i* (ı) for use in display type, where tight spacing and snug kerning cause many characters to touch each other. In these settings, the dot of an *i* can be particularly difficult to accommodate.

The dotless *i* is also often used when an accent would collide with the *i* dot (î í). These are most often found in foreign words and poetry.

Since a dotless *i* is, in the eyes of many editors, an alphabetic monstrosity, its use should be cleared with the proper editorial authorities. While occasionally seen in magazine and book work, the dotless *i* is most commonly used in advertising display type, where editorial monstrosities are more often the rule than the exception.

When space is tight, as in this ad type, use your font's undotted *i* to allow for snug letter placement.

Elliptical Thinking

We the People of the United States, in order to form a more perfect union . . . do ordain and establish this Constitution for the United States of America.

We the People of the United States, in order to form a more perfect union…do ordain and establish this Constitution for the United States of America.

The "handmade" ellipsis in the upper sample does a better job of highlighting the omission of text than the "canned" ellipsis found in many fonts and used in the lower sample.

The three periods used to indicate missing text . . . are called *points of ellipsis*, and fonts often include a character that consists of three periods that you can call up with a single keystroke. This is useful in theory, because points of ellipsis should not be broken across a line ending, and if you build your own ellipses using periods and word spaces, you're apt to have half on one line and half on the next. The theory has a flaw, though, because the periods of the ellipse character are so closely spaced that the character fails graphically to do its job: to show a clear break in the text that indicates an omission. Use this character only in display text, where tight spacing is the norm and can still be effective.

In text, the solution is to make your own points of ellipsis. But don't use your keyboard's space bar to create the spaces—use your program's nonbreaking space (consult your program's manual to find out how to make one—programs differ on how to do it). A nonbreaking space looks just like a word space, but your program cannot use it as a legal place to break a line. The spaces between the ellipses and the words they abut, though, should be normal word spaces to allow your program to use these junctures as legal line-breaking points. The idea is to have the three periods move as a unit but to prevent the ellipsis and the two words that flank it from becoming one huge (and unidentifiable) word in the eyes of your program's hyphenation utility.

When an ellipsis ends a sentence, it should consist of four periods—three for the ellipsis and one for the sentence-ending period. Only in this case should the ellipsis be joined to the word that precedes it with a nonbreaking space. This will prevent the ellipsis/period combination from starting a line of its own, which would look particularly odd at the end of a paragraph.

Feet, Inches, Minutes and Seconds

6′ 5″ tall, 36″ wide

6′ 5″ tall, 36″ wide

54° 36′ 24″ east longitude

54° 36′ 24″ east longitude

The italicized typewriter-style quotes in each upper sample are easier to use (and arguably better looking) than the primes traditionally used to indicate feet/inches and minutes/seconds and seen in the lower samples.

The correct symbols for indicating inches and feet and minutes and seconds are double *primes* (″) and single primes (′). These characters, however, are typically found only in *pi fonts* (fonts that include mostly nonalphanumeric characters and symbols—see Tip #52) such as the PostScript Symbol font. You can create a character that comes very close in appearance to these true primes by using italic versions of the typewriter-style single and double quotation marks straight from your keyboard. Make sure you italicize them, though, or they'll look like the humble typewriter characters they really are.

Dingbats can add a
touch of elegance
or inanity —
so use them with
discretion!

☞ Clip and save!

☑ **Yes!** *I want to
subscribe to
TofuWeek today!*

One pi character superimposed on another is part of this
coupon blurb's recipe for success—just add money.

Dingbats Are as Easy as Pi

Not all of the most common typographic characters are found in the
standard font layouts offered by type manufacturers. Traditionally,
these odd characters have been gathered together in collections
called *pi fonts*, so they are often called by the name pi characters, or
by their more historic appellation, *dingbats*. Try to find a good pi
font that contains the following characters. Each one listed below is
accompanied by tips on how to use it.

Many dingbats and characters come in both open (outline) and
solid (filled-in) forms. Because they have more weight on the page,
solid dingbats such as boxes and bullets can be used in smaller sizes
relative to the surrounding type than can open dingbats. A dingbat
should be bold enough to summon the reader's attention, but its
weight must be in balance with the surrounding type.

● Bullet

Bullets are simply solid dots in various sizes, usually ½ x-height,
x-height, ⅔ cap-height, and cap-height. They are typically centered
on cap-height. Always use a word space to separate a bullet from
the text that follows it. In a list of bulleted items, a ⅔ cap-height
bullet is about the right size and mass, with smaller ones being too
wimpy, and larger ones being too horsey.

■ Ballot Box

When solid, ballot boxes look like simple squares and are some-
times called, oddly, square bullets. Open ballot boxes, as their name
suggests, are typically used for "check here" boxes on ballots and
coupons. X-height ballot boxes should center on cap-height, and
cap-height ballot boxes should align on the baseline. A space
should be inserted between a ballot box and text that follows it.

✓ Check mark

The check mark is best used when it makes literal sense: in a
checklist or in conjunction with a ballot box. Check marks are more
informal than bullets, so use them sparingly in roles such as calling
out items in a list.

★ Star

Stars are more decorative than bullets, so you run the risk of look-
ing too cute when you use them—save them for appropriate deco-
rative roles. Use them followed by a word space, as with bullets,
and keep in mind that the design of stars gives them less mass on
the page for their size than bullets, so you may have to set them a
bit larger to get the visual impact you want.

▲ Triangles

These come in all orientations, and the ones that are rotated to look
like arrowheads are refreshing alternatives to bullets in listed items.
Cap-height triangles are the most effective in such lists.

#53 Don't Buy Fonts You Don't Need

Fonts can be categorized by how you use them, and the three basic divisions (in descending order of usefulness) are Text, Display and Decorative. Text faces are designed for ease of reading, and they're generally serifed faces like the one you're reading now. Display faces, which are used for headlines, titles and other attention-getting roles are often sans serif types and tend to be quite bold; in fact, bold and extra bold versions of text faces are often used in display roles.

Decorative faces, as their name implies, are gimmicky faces that are often evocative of a historic or artistic period (wild west, art nouveau, roaring twenties, etc.) or may imitate handwriting, or look like neon signage, or have letters constructed from logs and twigs, or be made up of paisley patterns. While eye-catching, decorative faces are not very versatile, go out of fashion quickly, and are in general the typographic equivalents of exercise bikes—they seem like a good idea at the time, but they tend to wind up in the closet very quickly.

If you're starting a type collection, focus on text faces that have strong bold and extra bold complements. You can design entire documents using three weights of the same face and their italic complements, with the extra bold weights serving as your display type. Stick with the classic faces (they're classic for a reason—designers and art directors rely on them over decades and centuries) some of which are illustrated here. You can get a lot of mileage out of one large typeface family, and you can be sure that you can mix and match the faces harmoniously.

The display face you use can change the whole tenor of your publication, so you'll want a number of them in your collection. Most of them should be sans serif, since you'll also be using your text faces for display purposes. Start with faces that have fairly normal letterforms (not too bowed, bulgy or having exaggerated features) as these blend best with the greatest number of text faces.

Avoid spending your money on a lot of decorative faces, though. You won't get much mileage out of them, and your readers will tire of seeing them. Also, because buying them is nearly irresistible, if you have friends doing desktop publishing they almost undoubtedly will have some that you can borrow when you feel the need to be fanciful.

The serif and sans serif typefaces shown at right are among the most popular faces in use today—all are "classics" that designers and typographers return to year after year. The selection of display and decorative faces is a potpourri of classics and not-so-classics that give you an idea of the range of variation possible among the same basic letterforms. In building your type library, emphasize the classic and versatile text and display faces, and keep the less flexible, decorative ones to a minimum.

SERIF FACES

Baskerville	A dignified 18th C. design good for books, reports, formal presentations
Bembo	Based on a 16th C. design, a classic book face, also good for journals
Bodoni	This 18th C. "modern" design is useful for titling and elegant presentations
ITC Caslon 224	An old saw goes, "When in doubt, use Caslon"—a good all-purpose text face
Century Oldstyle	Like Caslon, a versatile face for newspapers, magazines and books
ITC Galliard	Versatile, with lovely features, good for most anything but newspapers
Garamond Book	Based on a 16th C. design, this family's many weights make it very flexible
Times Roman	The classic newspaper face, also available in a slightly wider book version

SANS SERIF FACES

Antique Olive	Its very tall x-height makes it a favorite for signs and high-visibility ads
ITC Avant Garde	The uniform geometry of this face gives it a modern look
ITC Eras	Bold and slightly oblique, it's a dramatic face, epecially in heavy weights
Franklin Gothic	A classic display type, much more handsome and readable then Helvetica
Futura	A very popular, if cool, face that's currently in vogue for text and display
Gill Sans	A handsome and legible face available in a wide range of weights
Helvetica	The generic sans, it's overused, but its huge family makes it popular
ITC Kabel	A lively alternative to the classic sans faces such as Helvetica and Futura

DISPLAY AND DECORATIVE FACES

ITC Bauhaus	Its geometry may make it hard to read, but it definitely catches the eye
Broadway	Its name says it all—this face says "show biz" all the way
Clarendon	A classic 19th C. display type with bold serifs for excellent legibility
Cloister Black	A "black face" type now used for its antique or Biblical connotations
ITC Friz Quadrata	Based on classic Roman letterforms, this face has a chiseled elegance
Snell Roundhand	A legible script face perfect for invitations and elegant presentations
UMBRA	Gimmicky and arresting, if a bit hard to read

Similarly, the amount of space between the lines has to be in tune with these other two variables so that the page will have good color (an overall evenness of tone) and the reader will have an easy time scanning each line without visual "noise" from the lines above or below. Proper leading also helps the reader's eye quickly find the correct line to start on when returning to the left margin after finishing the preceding line.

Here's a handy rule of thumb for setting your leading:

Divide your measure (in picas) by the point size of your type (in points) and round off the resulting number to the nearest whole number. This figure is the amount of extra lead you should use. For instance, when using 12-point type over 26 pica measure (26 ÷ 12 = 2.166) you should add two points of lead, for a total of 14 points of leading.

This 10-point type is too small for the 34-pica measure it's stretched across. In addition, the tight leading—more appropriate to a far narrower measure—makes the lines of type difficult to read. The whole text block seems impenetrable and just plain uninviting.

When your line length gets too long for the point size you've specified, your reader is abused in two significant ways. First, the lines are so long that it becomes difficult for the reader's eye to land accurately on the correct line when moving from the end of one line to the beginning of the next. You can try to alleviate the problem by adding enough leading so that the reader's eye can easily follow the white path between the lines, but you may wind up with a problem like the one in the sample below. The second nasty effect for your reader is to create a page that's very, very gray, like your worst high-school textbook nightmare coming to life. Even if the point size you've chosen is in the traditional range, when you set it over a long line length the type looks tiny. Mismatched point size and measure is a particular problem when dealing with the standard 8½-by-11-inch office page, a large page by traditional publishing norms.

Here an attempt has been made to salvage the text block above by opening up the leading to 16 points. The line length is no less cumbersome, and this time the text block breaks up into stripes. The contrast created by looseness of the line spacing makes the lines of type seem even tighter, grayer and less readable.

If you try to correct a bad combination of wide measure and small point size by simply adding lead, your page will break down into a series of horizontal stripes. If your goal is mind control, this may have the desired effect of hypnotizing your reader. More likely, you'll just end up with a page that looks like a mess. A well balanced page should not have a particular horizontal "grain," even though it is indeed divided into horizontal lines. The balance of horizontal (interlinear) white space and vertical white space (between words and letters) should create an even texture to the page. When these horizontal and vertical tendencies of the page are in balance, the page will be more inviting to the eye and easier to read as well.

Using the measure as a starting point, you can calculate backward to figure out the ideal point size and leading ranges. The 13-point type on 16 points of lead used here is in tune with the measure, and the balance of vertical and horizontal white space in the text create an even texture throughout.

According to the formula in the accompanying tip, the 34-pica measure of this block of text calls for approximately 13 point type and 3 extra points of leading, for a setting of 13 on 16, which is how this block of text is set. This may be a little larger than type you're used to seeing, and you could probably get by with 12-point type. But in wide measures such as these, which have been made common by the 8½-by-11-inch office page used in laser printers, don't be afraid to set your type a little larger than is customary. It'll be easier to read that way, and your type will be more in proportion to the size of your page.

#61 Balance Word and Letterspaces

To fit type into lines, a typesetting program uses a process called hyphenation and justification (see "How a Computer Sets Type" in Chapter 11). To fit type onto a justified line, the program tries to expand or condense the word and letterspaces on the line to fully fill the measure. It's up to you to tell the program how much it will be allowed to distort those spaces.

The goal in setting word spacing, letterspacing and hyphenation specifications is to create evenly spaced type that makes reading easier and type handsomer by eliminating alternately crowded or gap-toothed type. Your overall spacing goal is good type color, consistent from line to line and paragraph to paragraph.

Generally, the program asks you to specify three values for word and letterspacing. These values are often percentages of "normal" spacing, which is the spacing defined by the manufacturer of the fonts you're using. Your program may also enable you to specify your own preferred value for a word space, again typically expressed as a percentage of that defined by your fonts.

The three spacing values you have to specify are:

Optimum—The optimum value is the letter or word space width that the program will use as a target when composing lines of type. The program will try to set your type using only your specified optimum spacing values.

Minimum—If your program can't fit the type properly within the optimum value, it will try to shrink the spaces to create a fit. The minimum value is the limit to which you will allow letter and word spaces to be squeezed.

Maximum—If squeezing doesn't work, the program will next try to expand spaces to accommodate the fitting of the line. The maximum value sets the upper limit of how far you will allow the program to expand those spaces to fill the line.

Programs vary in how they ask you to specify these values (some may ask only for minimum and maximum, for example) and some place limits on the ranges of stretching and squeezing you can specify. If high-quality typography is vital to you, make sure your program allows you to specify all three spacing values and places no restrictions on how tightly or loosely it will let you space your type. The values listed on the next page assume such control.

In general, letterspacing is more crucial to readability than word spacing, so keep letterspacing ranges limited so that your program does most of its justification work by manipulating word spaces. Here are basic values that will work (at least as a starting point) for most typefaces. You may have to increase the ranges when working in narrower measures:

> Fourscore and seven years ago, our fathers brought forth on this continent a new nation, conceived in liberty, and dedicated to the proposition that all men are created equal. Now we are engaged in a great civil war, testing whether that nation, or any nation so conceived and dedicated, can long endure. We are met on a great battlefield of that war.

This paragraph is set in what might be called "word processor style," that is, it's set without any controls exercised over word and letterspacing. The result is loosely set text with lots of unsightly gaps between words. The table below shows the spacing ranges used to set the type.

	Word Spacing	Letter-spacing
Minimum	100%	100%
Optimum	100%	100%
Maximum	100%	100%

> Fourscore and seven years ago, our fathers brought forth on this continent a new nation, conceived in liberty, and dedicated to the proposition that all men are created equal. Now we are engaged in a great civil war, testing whether that nation, or any nation so conceived and dedicated, can long endure. We are met on a great battlefield of that war.

In this block, the composition software has been given a range in which it can stretch and squeeze *word spaces* to justify the type. This takes care of some of the problems of the sample above, but it's still plagued by a lack of uniform spacing.

	Word Spacing	Letter-spacing
Minimum	75%	100%
Optimum	100%	100%
Maximum	125%	100%

Letterspace ranges for serif typefaces:
 Minimum: 95%
 Optimum: 100%
 Maximum: 115%

Word space ranges for serif typefaces:
 Minimum: 75%
 Optimum: 100%
 Maximum: 125% (150% in narrower measures)

Letterspace ranges for sans serif typefaces:
 Minimum: 100%
 Optimum: 100%
 Maximum: 110%

Word space ranges for sans serif typefaces:
 Minimum: 85%
 Optimum: 100%
 Maximum: 125%

How to Space Ragged-Margin Type

Traditionally, ragged-margin type has been set with fixed word and letterspacing, and often without hyphenation. This produces the most naturally spaced type, but may produce very wild (also known as deep) rags, especially in narrower measures. Because your program gives you subtle control over word and letterspaces, you can allow a degree of letter and word space alteration and still achieve a "natural" look. (See Tip #64 for more on rags.) Try these settings in ragged margin type:

Letterspace ranges for ragged margins:
 Minimum: 100%
 Optimum: 100%
 Maximum: 110%

Word space ranges for ragged margins:
 Minimum: 85%
 Optimum: 100%
 Maximum: 115%

> Fourscore and seven years ago, our fathers brought forth on this continent a new nation, conceived in liberty, and dedicated to the proposition that all men are created equal. Now we are engaged in a great civil war, testing whether that nation, or any nation so conceived and dedicated, can long endure. We are met on a great battlefield of that war.

With the ability to manipulate both word *and* letterspaces, the composition software can set type with very even and consistent color. The addition of letterspace control, for example, cures the loose first line here by allowing an extra word to fit gracefully within the measure.

	Word Spacing	Letter-spacing
Minimum	75%	90%
Optimum	100%	100%
Maximum	125%	125%

To set a fraction in a program that sets full-size superiors:

1. Set the numerator, fraction bar and denominator in the same size as the surrounding text.

2. Specify the numerator as a superscript or superior, and reduce its point size to 60% of text size. Set the superscript's elevation from the baseline as half of its new point size, rounded off to the nearest half point.

3. Set the denominator to the same size as the numerator.

4. Save the fraction for future use as described above.

Because of the variations among programs, you may have to do some minor tweaking to get the best alignment, but these basic recipes will get you very close to perfect the first time.

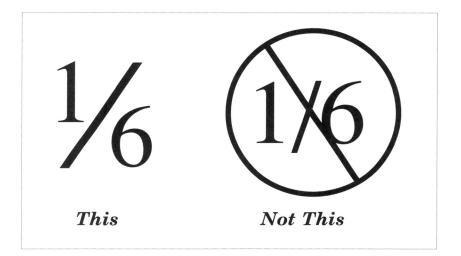

This *Not This*

#69 Kerning Number 1

All the numerals 0 through 9 have the same character width so they automatically align in tabular matter, such as financial tables. But the numeral 1 is obviously narrower than the rest. Because in text the numeral 1 always seems in need of kerning, it's tempting to add to your kerning tables a list of adjustments between 1 and the other numerals, the dollar sign, the comma and so forth. This definitely makes your type look better, but if you do it, remember to cancel kerning in all tables where you want your numbers to align.

CHAPTER SEVEN

BEYOND TEXT

In this chapter, we go beyond everyday typesetting and into the realm of special situations and special effects. While some of these forays simply look into unusual aspects of traditional typographic practice, many of them are based on the unique and malleable nature of modern electronic type. Not all of the following tips and techniques will be relevant if your printer uses bit-mapped fonts, which resist scaling and graphic treatment. But if your printer uses scalable outline fonts, there's some good advice ahead that could prevent a lot of unwarranted character assassination.

#78 Use Horizontal Scaling With Care

Horizontal scaling makes the characters of a typeface narrower, allowing more letters to fit on each line. The best use for horizontal scaling is as an eye-catching gimmick in display type. It can also be used in moderation as a copy-fitting device to pack extra type into a limited space, but this should be used only as a last resort, because scaling distorts the design of the characters.

Remember these basic rules:

- If you horizontally scale your text type, scale it throughout your document—don't just scale it here and there.

- If you are horizontally scaling your type as a copyfitting device, don't condense it by more than 5%. Electronically condensed type is harder to read.

- Don't use electronically condensed type if a genuine condensed version of the typeface is available. True condensed faces are designed as distinct typefaces and are superior in both design and legibility to electronically condensed types.

- Don't electronically expand text types—this makes them harder to read and can make them look downright peculiar.

Full faith and credit shall be given in each State to the public acts, records, and judicial proceedings of every other State. And the Congress may by general laws prescribe the manner in which such acts, records, and proceedings shall be provided, and the effect thereof.

Although extreme variations in character width make for unreadable type, they can be used to good effect in applications such as the drop cap here, a Bodoni F condensed 60%.

An electronically condensed face is not the same as a face that's been designed condensed. The top sample here is Futura Extra Bold Condensed, a true condensed face. The sample below it is Futura Extra Bold, electronically condensed to the same line length.

Fool's Gold

Fool's Gold

Radically altering the widths of characters generally causes unsightly distortions to the forms of the letters. The Avant Garde sample on top is condensed to 40% of its original width, and you can see how the vertical parts of the letters are narrowed while the horizontal parts are left in their original thickness. Round-bottomed characters normally extend a little below the baseline, but this usually unnoticeable effect is exaggerated here so that the *e* in Life appears to be sinking.

In the lower sample, set at 140% of normal width, the vertical strokes are fattened, making the horizontal elements appear too thin.

Houseboat Life

Boat Life

COMPOSITION SOFTWARE FOR PEOPLE WITH ALL THUMBS

COMPOSITION SOFTWARE FOR PEOPLE WITH ALL THUMBS

The upper sample was set all in Times Roman, but the weight of the smaller letters doesn't match well with the two towering T's. In the lower sample, the smaller type has been set in Times Roman Bold, and the match in weights is almost perfect.

Watch Your Weights

When you're creating display type consisting of characters of very different sizes, consider altering the weights of the typefaces you're using to maintain a consistent color throughout the type. Not all boldface types are equally heavier than their regular or book-weight family members, though, so there's no firm guideline on when the weight of a smaller-sized type can be bumped up and have it match the larger type around it. For typefaces whose bold is not really very bold at all, such as Goudy Old Style, those two sizes will be much closer together than for a family with a hefty bold, such as Century Schoolbook.

Generally, though, when the smaller type gets to about 50% the size of the larger type, you're in the range where the smaller can be set in bold and its weight will appear compatible with that of the larger. In addition, some families offer semi-bold faces—a weight between regular and bold weight—that you can use to create the same effect of matching weight when the two point sizes are closer together.

Offbeat Characters

When you electronically alter the shape of a letter, it's called an *anamorphic distortion*. Warping the basic letterforms is the stuff of advertising, where the gimmick can be as important as the message. It's also useful for logotypes, as long as the letters don't get so weird that they're unreadable. And this is the main danger in altering letterforms—that your design will defeat your message.

Anamorphic distortions are beyond the laws of typography, and the only rules you should be careful to follow are those of basic readability—keep in mind that people have a hard time reading type that's upside-down, set in mirror image, or undulating across the page on a 3-D ribbon.

Character fills—in which the outline of the character is filled with a color, screen, or pattern—are also easily created using desktop computer programs, but if you intend to image these on a phototypesetter, run some print samples first to make sure the patterns—especially the screens—come out the way you want.

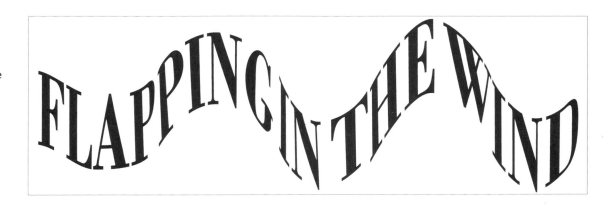

Outline fonts make typeset letters extremely malleable—perhaps too much so at times. Here, "Let's Get Crazy" looks as though it's printed on a football, which is an interesting visual effect, but the type at either end is becoming illegible. The eye is attracted to the center of the phrase first, which is not the way well-set type should work.

"Flapping In The Wind" is just too long, and the attempt at being evocative with the typography defeats the message—the type here has become more graphic than text and is too hard to read and recognize quickly. It's cute, but overdone.

"Fatso" works well. You can read it quickly, it's not too long, the letterforms are distorted but very legible, and—most importantly—the medium fits the message.

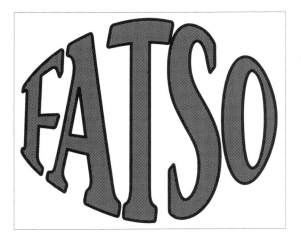

The last example shows how alien a simple letterform can become, in this case in a Halloween motif. If William Caslon could see what was being done with his classic designs ("Yikes" indeed!) he'd be spinning in his grave.

CHAPTER EIGHT

COMPOSITION TROUBLESHOOTING

What appears on your printed page won't always be what you'd hoped for. The best laid plans of mice and machines often go kablooey. Some of the problems covered in this chapter will be visible on the screen (if sometimes only to the particularly eagle-eyed), but many aren't apparent until the proofreading stage. Even the most adept typesetter has to perform damage control sometimes, and this chapter provides an inventory of some of the most common—and most subtle—mishaps that can befall a composed page.

even if you can't see a particular typeface on your printed page, it could still be lurking there in a word space, or perhaps camouflaged in a bit of punctuation. This happens very often when a passage of text has been specified as italic and then converted back to roman — whoever does the editing may change the typeface of the *word*, but inadvertently leave an italic word space or piece of punctuation behind. When it comes time to print, your program may have to download the italic font just for the sake of a word space. This extra font may overload the printer's memory and your page will fail to print. Or, the hidden fonts may simply slow down your printing by forcing your program to automatically download unnecessary fonts over and over again.

Most composition programs enable you to take a font-use inventory of your document, and it's a good idea to do this before finalizing your publication. If you find a font listed that doesn't belong in your document, you can use your search-and-replace utility to locate its appearances.

#90

Clean Up After Your Editor

In the good old days, when a manuscript went to the typesetter it was out of the reach of editors and authors who are chronically incapable of letting go of it without just one more change, or two, or three. A bane and blessing of desktop-published manuscripts is that they're vulnerable to wholesale editorial changes after they've been composed into pages. Even when editors and authors have shown admirable restraint in keeping their mitts off composed pages, fairly extensive editorial changes may be necessary for copyfitting reasons.

In any case, you should use your program's search-and-replace and spelling checker to mop up after these last-minute changes. In particular, be on the lookout for:

- Double word spaces
- Missing ligatures
- Typewriter-style quotes
- Faulty fractions
- Improper dashes
- Unitalicized primes (see Tip #51)

CHAPTER NINE

PRINTING

Most of the unpredicted events in typesetting occur during printing. For the most part, the printed page is the smoking gun of felonious formatting, but apart from that, when printing, you'll face pages that take forever to print, pages that won't print at all, and pages that print in the wrong typefaces. And the printer of your dreams—the one with enough storage for all your fonts—is too often only the stuff of dreams, leaving you to make do with limited memory. By following the tips in this chapter, though, you'll be able to make the most of what your printer offers by printing smarter, faster and clearer.

#91 Font Downloading Strategies

Your printing will go much quicker when all the fonts your documents need are already in the printer—either built right into it or stored in memory or on a hard disk. When the fonts aren't in the printer, they have to be downloaded into it, either automatically or manually. Automatic font downloading is done by your composition program, which sends the printer the fonts needed for the job being printed, after which they're dropped from the printer's memory. Manually downloading fonts—using a special program to copy them into the printer—installs them "permanently." That is, they stay there until they're erased (see "How Your Computer and Printer Handle Memory" in Chapter 11).

The problem is that most printers don't have enough memory to store as many fonts as you use in the course of a day, so you have to decide which ones to load permanently and which ones to let your program download temporarily. The logic of choosing manual or automatic downloading depends on how much memory is available in your printer—the more storage that's available, the more fonts you can store there permanently. If you're going to be printing a number of different jobs using several different sets of fonts, it's probably impossible to store them all permanently in your printer unless it's equipped with a hard disk.

So keep this fact in mind: It takes about ten seconds for your program to automatically download a font to the printer and about a minute to turn the printer off and on again to clear its memory and get it ready to print again. This means that if you have to sit through more than a half-dozen automatic font downloads, it's probably faster in the long run to download the fonts manually, and then turn the printer off and on again to clear its memory for the next job. When you're going to be doing a couple of proof prints of a job before your final printing, this strategy makes even more sense.

#92 Avoid Rotated Bit Maps

Bit-mapped images—such as images in various "paint" formats—generally print quite quickly, but if you rotate them, they can slow printing to a crawl. This is especially true with halftone photographs (photos that have been reproduced as an array of dots) and other high-resolution, complex bit-mapped images.

The raster image processor of your printer has no problem placing the dots of a normally oriented bit-mapped image onto the digital grid of the page (see "About Digital Type" in Chapter 11).

When the image is rotated, though, the computer has to make an enormous number of decisions about placing dots that no longer align in neat horizontal rows. To reconstruct the image at an angle—to essentially re-map the entire image—can take a lot of time. On high-resolution phototypesetters, this amount of time is multiplied several times over.

If you're going to rotate bit-mapped images, try to do it in your paint or graphics program instead of in your page composition program (so it can struggle with the rotation instead of your printer) or rotate your images only in 90° increments, which aligns the dots of the bit map back into horizontal rows that are easier for the computer to handle.

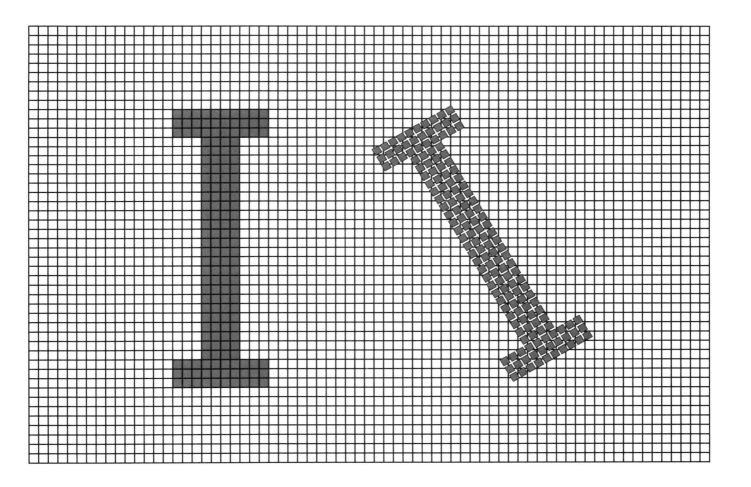

The character on the left represents a bit-mapped graphic as it was intended to be printed, with all its pixels aligned neatly on the imaginary digital grid of the page. When the same character is rotated like the one on the right, the pixels fall out of alignment with this grid, and the raster image processor of your printer has to work hard to re-map all of the bits. For this reason, rotated bit maps—especially complex ones or those printed at high resolutions—can take a long time to print.

#93 Take Care when Scaling Bit Maps

Just as rotated bit maps slow printing, scaling bit maps can bog down your printer as well. And just as with rotations, the more complex the scaled bit map, the slower printing can get. Scaling at certain percentages, though, is easier for your printer than others. On a 300 dot-per-inch printer, for example, reducing an image to 50% lets the printer throw out every other dot of the bit map to shrink your image. At 75%, it can throw out every fourth bit. At these common-denominator percentages, scaling can proceed more quickly, often as fast as for an image printed at 100%. In addition, your image will print at its highest quality at these percentages.

But at, say, 84%, the raster image processor has its work cut out for it, as it tries to maintain the graphic integrity of the image while shearing pixels off the image here and there to shoehorn into the resolution of the page. On higher-resolution printers, such as phototypesetters, there are more common denominator points (although more dots to cope with as well), and some composition programs can automatically determine these points for you depending on the printer you've selected.

#94 Minimize Proof Printing

During the process of page-building, it's tempting to print progressive proofs to check kerning, alignments, layouts and so forth. But printing these proofs can take up a lot of time and eat up a lot of paper, so you should avoid them whenever you can.

When you're kerning a headline, though, or adjusting a graphic, or doing some other fine work that necessitates printing intermediate proofs, try pasting the element you're working on onto a blank page at the end of your document and editing it there. Then your progressive proofs can be of just that single element on that single page. When you're happy with the results, paste it back into its proper position.

Also, if your printer is built to handle it, you can recycle your proof pages by printing on the back sides of the sheets (see Tip #95).

You can also save a lot of time in proof printing by having your program suppress graphics during printing. This will leave a grayed-out area or a blank space on your page in lieu of the image, but your printing time will be greatly reduced, because graphics take more time to image than type.

#105

Patchwork Pages

Even if you follow Tip #104 assiduously, there will be pages you'll have to set twice. But don't throw the original defective pages away. The photographic paper your pages are set on is chemically stabilized and should maintain its good looks for at least a year before it begins to discolor or degrade. Maintaining a file of all your old bad pages gives you a gold mine of potential corrections for future misset pages. Cannibalizing these old pages for corrections and stripping them into new ones can save you a lot of time and headaches, especially when deadlines loom.

When you're patching your pages from old spare parts, remember that the *density* of typeset pages varies. Phototypesetting is very much like camera photography, and your service bureau may overexpose or underexpose your page film on any given day, resulting in darker or lighter type. Type from different bureaus will also vary in density. Even slight variations in type density can be apparent on pages that have had corrections pasted into them—a phrase, line or paragraph may pop out on the page because it's too dark or too pale. Always take note of how your patches blend in with the rest of the page before you paste them in.

#106

Marginal Corrections

The idea of a wholly composed, pasteup-free page is very appealing, but there's no sense in resetting an entire page to correct a small error (see Tip #105). When you have a minor correction to make to a page, just have the needed type block set. But don't make the corrections too small—it's much easier to align a whole-paragraph correction than a single word or line.

When you need to set a correction, piggyback it on another page you're having set. Service bureaus generally charge you by the page, so if you can sneak a little correction patch onto another page, you can have your corrections set for free.

If you have publications that you do on a regular basis, it's also a good idea to phototypeset a page of common corrections such as a selection of page numbers for use on pages, indexes and tables of contents; a stock of "continued on page x" jump lines; spare logotypes in various sizes; and an assortment of rules of various widths.

#107

Matching Fonts and Software

Most service bureaus have an extensive font selection, but you should always verify that they have all the fonts you've used in your pages. If you've customized the kerning tables in your fonts, you'll somehow have to supply those exact fonts to your service bureau. If you're printing with PostScript fonts, the safest way to do this is to send them your file in PostScript format with the fonts included in the print file (see Tip #102).

If you have to supply fonts to your service bureau, you must make it clear to them (although they shouldn't need any reminding) that the fonts are only being loaned to them and that after the job is complete they have to delete any copies of the fonts they've made. This is to keep you within the bounds of the purchase agreement you made when you bought the fonts (see Tip #46). In addition, you should supply a matching set of screen fonts for them to use if their system demands them.

Likewise, it's important that your service bureau use the exact same version of the composition program that you used to create your pages. If not, you'll have to supply a copy of the program too, on the stipulation that any copies they make be deleted after the work is done. Again, if you're working in PostScript, you can save your file in PostScript format and avoid having to send a copy of your composition program along.

Finally, try to be sure that both you and your service bureau are using the same versions of your operating system software. This isn't likely to be a big problem, as newer operating systems are almost always compatible with previous versions, so that your only worry is the unlikely case that you're using a newer version than your service bureau.

#108

Flat-Rate Pages

Unless your pages are all text and set in a limited variety of point sizes, find a service bureau that charges a fixed fee per page instead of a per-minute or other imaging-time-based charge. A seemingly simple graphic that printed fairly quickly on your laser printer may end up taking an hour to phototypeset (see Tip #109), and when you're charged by how long it takes for your pages to print, you may suddenly be faced with a $90 page. A service bureau that charges a flat rate per page is insurance against this happening.

If your pages are very simple, though, and you're sure they're going to print quickly, a charge-per-minute shop may be your best deal, because a flat-rate shop has to factor slow pages into their

standard fee. If you don't create any slow pages, your flat-rate payments are subsidizing people who do.

#109

Slow Begets Slower

If you create a page that's slow to print on your laser printer, you can be sure that it will print even more slowly on a phototypesetter, which has so many more dots per page to deal with.

If you're sending your files to a charge-per-minute service bureau (see Tip #108), you may be in for a very expensive page. And if you send to a flat-rate shop, you might not get your pages back as soon as you'd hoped—these shops can't afford to tie up a $75,000 typesetter waiting for your pokey page, and they may wait to run it at the end of the day, letting it image after they've gone home for the night.

Make a note of any slow-printing pages as you create them, and see what you can do to simplify them. Don't worry about pages that are slowed by a lot of automatic font downloading, though, as most phototypesetters have all their fonts stored on a hard disk, eliminating automatic downloading altogether. The most likely culprits of slow pages are complex draw-program graphics and complex scaled or rotated bit maps (see Tips #92 and #93).

#110

Direct to Film

Phototypesetters are capable of creating your pages as positive images on paper film or as film negatives. These latter pages can be given directly to your print shop, who can use them to make printing plates without further ado. The negatives are laid over photosensitized metal plates and exposed to a bright light, which burns the image of your page onto the printing-plate surface. When treated with chemicals, the image areas of the plate will carry ink, and the white space on the page will resist ink. The inked image is then offset onto paper, which is how offset printing gets its name.

Potentially, imaging your pages directly as film negatives cuts out a step in the pre-press process, in which the print shop takes the positive page images that you supply and photographs them to create their own film negatives. Not all print shops like dealing with film that comes from phototypesetters, though, so check with your print shop before committing to the process. If they're interested, image a sample page for them to test. Your service bureau may also be familiar with printers in your area who handle such film. Cutting out the double-imaging of your pages can save a lot of money in your print budget.

If your printer gives you the go-ahead, you'll have to be more careful than ever about sending only perfect pages to your service bureau, because film-negative pages can't be patched like paper positives—if there's an error on the page, it has to be completely reset. Also, film negatives are more delicate than paper positives, so handle them with care.

#111

Type To Go

It's good to remember that just as desktop publishing has made typesetting much less expensive for you, it's also made it much less expensive for the commercial type shops as well. This means that even though it's still cheaper for you to do it yourself, it's also pretty inexpensive to have someone else do it for you. When time is tight, consider the value of your own time when deciding if it's really most economical for you to set your own type, or whether it might be worth it to hire the job out. Many type shops work two shifts, and have their people tickling the keyboards late into the night. When there's typesetting to be done at midnight, it's a far, far better thing to let someone else do it. Then you can take advantage of the economy of desktop publishing by *not* doing it yourself.

#112

Serve Advance Notice

A professional courtesy that will ensure you better service from your service bureau is to always notify them in writing of the nature of the jobs you give them. The best way to do this is for you to maintain a checklist of the important aspects of your pages, including:

- a list of fonts used in the document, especially any custom-made or custom-edited ones

- an indication of the originating program, complete with version number

- a list of complex graphics and what pages they appear on

- a warning about any particularly slow-printing pages

- the existence of oversized pages or pages with oversized image areas

- a list of all linked files (for composition programs that don't import all constituent files directly into the print file)

GLOSSARY

Everything from algorithmic hyphenation to x–y coordinate mapping — here are 203 definitions that demystify the ancient jargon of type and the computer-speak that's invented as fast as we can figure out what it means.

A

algorithmic hyphenation: A method for hyphenating text that uses a mathematical logic program instead of a dictionary to deduce legal hyphenation points of words.

alphanumeric characters: The standard alphabet, numeral and symbol characters that appear on the keyboard and compose most typeset text. These do not include symbols such as dingbats, pi characters and miscellaneous nonprinting characters, spaces and symbols.

alternate characters: Characters outside of a font's standard character set such as special ligatures, old-style numbers and alternative letter shapes for display type.

anamorphic distortion: A change in the basic shape of a letterform created by electronically manipulating its outline.

AppleTalk: The network protocol of Apple Computer products, also used for connecting computers to printers.

ascenders: The upward reaching strokes of lower-case letters such as *d* and *b*.

ascent line: The imaginary line to which a typeface's ascenders reach.

ASCII: The American Standard for Computer Information Interchange, a standard for communication between computers that assigns numbers to the most commonly used alphanumeric characters; sometimes called text-only format. See also *low-bit characters* and *high-bit characters*.

AUTOEXEC.BAT file: On IBM-PC compatibles running the Disk Operating System (DOS), a file that contains a series of commands that are automatically read and executed upon start-up of the computer; the name stands for *automatic execution batch* file.

automatic downloading: The temporary downloading of fonts to a printer by an application program while printing a document.

B

backslant: The obliquing of a character that causes it to be inclined to the left instead of the right.

ballot box: A square pi character or dingbat that may be in outline or solid form.

baseline: The invisible line upon which the characters of a typeset line appear to sit.

baseline shift: In desktop publishing programs that consider leading to be a paragraph attribute, an adjustment to the leading value of select characters within a paragraph.

batch pagination: The automatic assembly of fully composed pages carried out by a program following predetermined composition and page layout rules.

Bezier curve: A curve marked by two control points that lie off the curve but which when moved alter the shape of the curve; this curve is used as the basic line descriptor in PostScript and for building the outlines of PostScript fonts. See also *conic spline* and *PostScript*.

binary: Describes information stored or expressed as a series of on/off, yes/no or 0/1 statements.

bit: The fundamental unit of computer information representing one on/off, yes/no or 0/1 decision.

bit map: An array of dots that comprise an image on either a computer screen or a printed page.

bit-mapped font: A font whose characters have been stored as a discrete array of dots intended to be imaged at a specific resolution and point size.

black: A typeface weight heavier than extra bold.

bleed: Describes a printed page element that extends beyond the trimmed edge of the page.

bold: A typeface weight that is heavier than regular or book weight but lighter than extra bold.

book: A typeface weight intended for text use whose weight lies between light and semi-bold or bold; sometimes called regular.

brush: A typeface designed in imitation of letters created with a brush and ink.

bullet: A round pi character or dingbat that may be in outline or solid form.

cache: In a computer or printer, a storage area in memory or on disk where program information, page bit maps or character bit maps are stored for future use and fast retrieval.

camera-ready: Describes completed pages or artwork that are ready to be photographically prepared to create printing plates.

cap height: The height of the uppercase letters of a typeface.

carriage return: Also called a return, a keyboard command that ends a line and starts a new one, typically signaling the end of a paragraph.

centered: A margin treatment that takes the leftover space of a typeset line and distributes half at the right margin and half at the left margin, causing the text to be set midway between the two.

character set: The entire collection of letters, numerals and symbols in a font.

character width: The width of a typeface character expressed in relative units.

color: In typography, the gray tone created by a mass of type, as in an entire book page.

compressed: See *condensed*.

condensed: A typeface whose characters have been designed to be narrower versions of the regular-weight typeface in the same family; also called *compressed*.

conic spline: A curve based on the shapes obtained by slicing an imaginary cone at various angles; this curve is used for building the outlines used in TrueType fonts. See also *TrueType*.

decorative: A typeface designed to be eye-catching and often whimsical, used in display roles to evoke a specific mood or feeling.

defaults: The page, typographic and program settings that are already in effect when an application is started up.

density: In phototypesetting, the darkness of the typeset image, as determined by the intensity of the exposure of the photographic film or by the nature of the film developing process.

descenders: The downward-reaching strokes that extend below the baseline in lowercase letters such as *y* and *g*.

descent line: The imaginary line to which a typeface's descenders reach.

digital: Describes computer information that has been stored or communicated in binary form (as a series of bits).

digitize: To convert information into electronic form by translating it into a series of bits.

dingbat: A nonalphanumeric typographic character used for visual emphasis, for decoration, or to create printed borders.

diphthong: In typography, a vowel ligature such as œ or æ.

discretionary hyphen: A command embedded in a word that signals to a composition program a legal point at which to insert a line-ending hyphen.

display PostScript: An adaptation of the PostScript page description language specifically used for driving the screen of a computer.

display type: Type set in sizes larger than text type (usually 18 points and above) and used for signage, headlines, titles, call-outs and the like.

download: To pass fonts from a computer to a printer for use in printing pages, where they are stored temporarily (for the duration of one print job only) or permanently (in memory until the printer is turned off, or on a hard disk until it is erased).

drop cap: The enlarged first letter in a paragraph that sits below the baseline of the rest of the first line of type.

em: A unit of measurement, expressed in points, equal to the point size of type in which it is used.

em dash: A dash that is one em wide.

em space: A space on a typeset line that is one em wide.

em square: The basic matrix in which characters of a typeface are designed, it is one em wide by one em deep and encompasses the width of the widest character in a font and reaches from above the face's tallest character and below its deepest-descending character.

Encapsulated PostScript Format: A format in which PostScript images can be saved that defines certain ambiguous characteristics about a PostScript file; it enables an application program to place in pages and display on screen any PostScript file saved in this format.

en dash: A dash that is half the width of an em dash.

en space: A space on a typeset line that is half an em wide

EPSF: See *Encapsulated PostScript Format*.

expanded: A typeface whose characters have been designed to be wider versions of those in a typeface in the same family; also called *extended*.

extended: See *expanded*.

family: A group of typefaces that have been designed to be used together, typically including roman and italic versions, several weights of each, and often serif and sans serif versions as well.

feathering: The slight incrementing of leading between all the lines in a passage of text with the goal of extending the text block to fill a space or push text forward to the next column or page.

figure space: A space on a typeset line equal in width to a numeral in that typeface, used for aligning numbers in tabular matter.

first-line indent: An indent on the first line of a paragraph, also called a paragraph indent.

fixed spaces: Typeset spaces whose widths—unlike those of word spaces—remain constant during hyphenation and justification, including em spaces, en spaces, thin spaces and figure spaces.

flush left: A margin setting in which all lines begin flush against the left margin. Any space left over in a composed line is deposited along the right-hand margin, if the measure is not justified.

flush right: A margin setting in which all lines set flush against the right-hand margin. Any space left over in a composed line is deposited along the left margin.

folio: In typography, the page number printed on a page.

font: The physical form through which typefaces are reproduced on a computer screen or imaged on paper or other surface; a drawer of metal type, a filmstrip bearing character images, and a digital description of a typeface saved on a computer disk are kinds of fonts.

font substitution: A printing error in which one typeface appears in place of the intended one because the correct font was unavailable to the printer or because of a mix-up in font identification in the raster image processor.

forced justification: The forced stretching of a short line to fill the measure, even though this stretching violates the specified hyphenation and justification settings.

frame: In electronic page composition, the invisible box that bounds a type or graphic element on the page.

galley: In typesetting, a typeset proof consisting of single columns of type not composed into pages.

grid: In page design, the underlying structure of the page, composed of vertical and horizontal guidelines that define column boundaries, text positions, graphic positions, etc.

gutter: The blank vertical band that separates columns of type on a page.

h&j: See *hyphenation and justification*.

hairline: A fine rule measuring less than ¼ point in thickness.

hang line: In a page grid, a line that forms the top alignment point of a graphic, rule or box.

hanging indent: An indent in which the first line of a passage of text sets flush left and succeeding lines are indented, leaving the first line extending out to the left. This glossary is set with hanging indents.

hanging punctuation: A style of setting type in which punctuation that starts and/or ends a line extends outside of the measure and past the column margin of the type.

hard hyphen: A hyphen that is part of a word and not inserted by the composition program, as in the word *hard-hit*.

high-bit characters: The ASCII characters numbered 128–255, which are outside of the standard ASCII character set and whose identities may vary from font to font and computer to computer. See also *ASCII* and *low-bit characters*.

hints: Electronic coding added to a font that assists low-resolution printers in placing its dots to build optimally legible characters, especially in small point sizes.

horizontal scaling: Electronically altering the width of the characters in a typeface to make them set wider or narrower; expressed as a percentage.

hyphenation and justification: The process a composition program uses to fit type into lines of a specified length; it relies on the ability of the program to stretch and/or condense word and letterspaces and to hyphenate words to fill lines of type within specific spacing limitations.

imagesetter: A phototypesetter that can also create graphic images, making it capable of imaging completely composed pages with all text and pictorial images in place. See also *phototypesetter*.

indent on text: An indent triggered at a point determined by the position of typeset text on a line rather than on an absolute distance from the margin, as in a hanging indent that is set to the width of the first word of the first line in a paragraph.

italic: A typeface design based on an oblique script style originally created in imitation of calligraphy; italics are typically designed as complements to specific roman typefaces. See also *obliques*.

justification: The process of filling lines with type; justification attempts to fit as many characters as possible on a line (within specified spacing limits) and distributes leftover space at the right margin (flush left), the left margin (flush right), evenly at both margins (centered), or among word and letterspaces (justified). See also *hyphenation and justification* and *forced justification*.

justified: A margin setting in which leftover space in a composed line is distributed between word and letterspaces in that line, forcing the text out flush against both margins.